This book was written by Connor Miller
www.connorthemiller.com

Cover: *Rouen Cathedral, red, Sunlight*, Claude Monet, 1892

ISBN: 978-1-949127-44-7

DEEP OVERSTOCK
P U B L I S H I N G

onnor Miller

FARTHEST AWAY FROM PERFECT

or Nick

TABLE OF CONTENTS

INTRODUCTION

My friends are afraid of poetry. They tell me that poetry feels like a coded language or an exclusive club, one that they haven't been invited to. Imagine sitting and trying to read a poem, knowing you are supposed to feel something but instead just feeling like a fraud. "Maybe I just haven't had the right teacher," someone told me. "Or maybe I just don't know where to start."

For me, poetry started with e.e. cummings - I watched a stage performer break down their favorite e.e. cummings poem for thirty minutes. The poem couldn't have been more than 200 characters long, but somehow the performer had found endless tricks and flourishes and

images that expanded the depth and the impact of the poem. Before that night, I would have looked at the words and seen nothing. Now, I see that poems are intimate, and that they are enriched by the attention and love we give to them.

Or, maybe, poetry for me started with the slam poet Derrick C Brown, who I heard on a podcast when I was in high school. His poems are funny, sincere, and approachable - sometimes he reads them to open for rock bands. I learned that poems don't have to necessarily be so abstract that you cannot understand them - the purpose of a poem, perhaps, is to tell stories. Derrick Brown wins the trust of his audience with humor, then in turn breaks their hearts with colorful sincerity. I bought as many Derrick Brown books as I could, and followed him across the country to see him perform live. "Sometimes, we just throw Derrick onstage to see what happens," a friend told me once. Poetry, and stage presence, seemed to ooze from Derrick Brown, and it made me want to do the same.

Maybe poetry for me started with Nick in San Francisco, when he flung his apartment door open to greet me with Tender Buttons, a short book of poems by Gertrude Stein. "The sudden spoon is the same in no size!" he sang to me in a silly voice, "The sudden spoon is the wound in the decision!" Up the stairs, he read me more poems. As he got dressed, more Tender Buttons. All the way back out for burritos and drinks, more poems, all the way to Mission Dolores Park where he sat beside me in the grass and finished out the book. Nick taught me the magic of sharing poems, and reading them fully with your whole heart.

Or, maybe poetry for me started in Portland Oregon, at midnight in a dingy bar with my friends, as we huddled around beer and pizza, writing haikus on scraps of paper. Or maybe it was in Seattle, reading Mary Ruefle in the snow and weeping. Or maybe it was writing my first sonnet in high school. Or maybe it simply was always there, and all I needed was to be shown that, yes, poetry was for everyone, poetry was for me, and that the best poetry was the kind that felt like it was letting me in on the secret, rather than scaring me away.

My friends who are afraid of poetry just need to be let in on the secret, in the same way I'd bring them to my favorite basement speakeasy. Here's the entrance, here are the regulars, here's how you figure out what you like - hopefully we can find something for you that makes you want to come back to experience the full spectrum of what poetry has to offer.

Connor Miller

BEING ALONE
(VERY ALONE)

1.8.15

Aren't you supposed to be
listening
 listening
 listening

[The fan in my laptop
wheezes, someone has
turned on the stove,
someone has turned
on a light]

Why have so many things
stopped being funny to me?

Today
I
was
so
angry
(I had a headache).

Today
I
got
a
lot
done
(applied for jobs).

I

cooked
myself
dinner
(Frozen orange chicken)

I
had
a
beer.

(soft
wind,
foot
falls,
the
geometry
of
the
building
across
the
street)

there
were
baubles
in
the
trees.

And
Christmas
lights
wrapped
around
the
branches.

B texted me.
L texted me.

(Listening
and
hearing
very
little,
maybe
just
your
heartbeat,
your
bloodstream
the
electricity
in
your
brain).

1.10.15 San Francisco Haikus

"In San Francisco
I think it's, like, Halloween
once a month, at least."

What if we never,
after two hours waiting,
received the tortas?

"You were my RA
for summer camp SLC."
"Yeah, word. I dropped out."

"That's a coconut.
He just hacked away at it
with a machete."

"You should talk to them.
If you don't I will kill you.
I am serious."

Nick dances around
through Mission Dolores Park
wearing my headphones.

Uh oh, where is Nick?
I have lost him in the park.
Somewhere, he's dancing.

1.11.15

wake up!

(rumble rumble rumble)
(rumble rumble rumble)

he is
asleep
on
his
luggage
he
is
asleep
on
his
luggage
he
is
asleep
on
his
luggage

wake up!
wake up!
wake up!

(rumble rumble rumble)

1.19.15

It is not
 genius
it's
 caffeine.

It is not
 God
 it's
 us [in the future].

It is not
 love
 it's
 a recipe

It is not
 so
 many
 things

It is
 lacking
 a
 wholeness
 a
 truth

It is
 lacking
 what it's
 supposed
 to
 be.

1.26.15

shnazzyangularcleanwithcorners
sharpandsmooth
pastel
blue
framed
maps
of
vintage
island
getaways.

1.26.15

To get drunk (while listening to Alice Coltrane)
To enjoy wine you found hidden in the back
of Whole Foods ($3!)
To push your hair back and sink
into
a
couch.

The pang of *"tomorrow I need to…"*
The comfort of *"tomorrow I will…"*
The *"I am going to enjoy this because it will*
 help me and be good for me in
 the long run."

(laughs)

To get drunk.
To run your fingers through your own hair
while listening
to
Alice
Coltrane.

1.26.15

Love
may
be
feeling
dumb,
inadequate,
insubstantial,
in
front
of
someone
who
knows
that
you
feel
this
way,
someone
who
holds
your
hand
regardless.

2.2.15

hm

an
understudied
suffercake
nitpicking
fun, fumbling
dorked.

2.3.15

Hushed and it's numb/nasal
underfumbling, reddish
listy and normal, the
northwest, the horrid minus
the avid and the sniff! or
habit, neon, shoelaces,
pronounced eyerolling
and eyeballs fixed at
an open expanse of lake.

2.13.15

Sing the songs so they
 echo.

The holes are
 deep,
 cavernous.

There aren't any
 survivors.

The last hunt
 yielded
 nothing
 (very little)

The last hunt
 truly
 was
 the last

Sing your songs so that they echo,
 "Do you love me still?"

(She listens
and waits)

2.22.15

I MAY NEVER WIN AN AWARD
FOR MY POEMS
BUT MAYBE THEY
WILL LOVE YOU
MORE THAN I CAN
IN THIS MOMENT.

2.27.15

If I lick a small index card and
affix it to my forehead,
 I will raise my arms up
 in a crooked and broken V
 in the celebration of it,
dance around, work, go
about whatever I have
to go about.
I want it to be blank
I want it to fall off
without me noticing
I want to forget that I even put it there
in the first place.

2.27.15

WANTON, PERVASIVE, EARLY.
TORCH-HUMMERS SIP RELAXED.
FOXING NOT ONLY BUT VISCOUS
TISSUE-BEAKERS, A SAD SACK
FAT WITH GROW-FISH, SORE
CATARACTS AND GOOP.

3.10.15

This is not love,
it is an absence of,
it is a thick blanket
that I curl around,
it is a heaviness
to breathe.

3.10.15

To build a
tent in your
living room with
flashlights and
ghost stories!

A cliché I
want so badly
that i makes me
question the initial
evil of cliché.

3.11.15

The poem
often
comes in
odd moods
of mine,
I try
and try
to be
conversational,
accessible,
important,
relevant,
when
I
truly
am
just
a
garbled
joy-mess,
self-conscious,
and by no means
an expert
on how to feel
or live.

3.11.15

The five-pointed star or six-pointed star
or seven or eight or nine

the

hardest part about
the hardest part
is the last time
you counted the spaces
between constellations

where is the person
I can count empty spaces
with?

I am here!
I am here!

3.13.15

Tiny
children
sitting
in
adult-
sized
chairs.

3.27.15

warped
songs
about (around)
guitars and coffee dates
warped
chest pain (lumps)
cursing and getting
to know someone
new.

a genuine
care
hurts
and
scares
like a rock
thrown from
a
lover
hiding
behind
a
tree.

warped
songs
on
the
record
player,

her
voice
is
bent
at
odd angles,
swerved and staticky.

the
openness
the ask / the question
"What do you like?"
"Where do you live?"
"How do you like Portland so far?"

I am
unfinished and left
with a stack of these
questions
concerned with
why (how)
they
made it here
in
my
hands.

3.27.15

orphaned
nutjobs
sordid
faithful
fancy
un-true.

candid
but not
filthy
guessing
how each
piece
turrets
the
last.

corner
store
worship.

peanut
girl
laziness.

copious
funding
over
a
cancellation
or
a
cause.

3.27.15

I want to make sense of
you again, I want to
stop having to tap this
chalk on my lip and
I want to stop having
to scratch my head beneath
this chalkboard,
I want to turn my
back to it and to
forget what it means
to figure out.

I have read the psych
articles about love and
all of the conditions
necessary for its
growth and the
more articles that
flood my newsfeed
the less I want
anything to do
with it.

B-SIDES

5.19.18

cold neck
cold shoulders
doggos & groggy
fog head and
love drunk
waiting for
that that
that that
ping on
my phone
from

5.19.18

a pause
before I
write the
word "a
knife before
I thought
I might"
a pause
and
here you
are eyes
open in
the morning
as I cold
your shoulders
soft a knife
keeps coming
between

5.22.18

sitting ("galloping")
because coffee sends
my mind galloping

because mornings send
my heart galloping

because each feature
of your face sends
my fears

6.27.18 "Nabokov Weekend"

I find it so frustrating that
I don't have the
words to describe how
you smell.

You, on the other hand, manage to
see a spectrum of colors,
each shade specific to the
ways we kiss.

I feel a spectrum of nameless things,
all too big or
fleeting or specific to
nail down into a poem
or a box.

They burst from my chest each
time you throw the alleyside
door of your building open,
your arm extended like a
Sondheim welcome ("Hellooo
my love," you sing).

An entomologist locks the doors of the
natural history museum to meet
you for a picnic somewhere
on the outskirts of town.

The hills are green, the air is warm,
and there is a swarm of

butterflies, unnamed and
undiscoverable, swirling around
us.

Maybe words were always the wrong medium.
Maybe our hearts only speak in colors.

7.11.18

Every morning I wake
up with a song already
playing in my head
as if I fell asleep
with my brain radio
on (or as if someone
fiddled with the dials
as I was sleeping).

7.11.18

In *Paterson*, Adam Driver plays
a poet who is also a bus
driver. The poems in the film
were written by someone else,
I forget his name but I
could look it up.

In this sushi restaurant, I am
a writer who is also a "store
associate". I am definitely writing
this poem but it feels like
I am pretending to be Adam
Driver pretending to be someone
else.

In your apartment, I am a
lover who is also a friend.
Here, I am never pretending
to be anyone other than
myself, which means sometimes
I worry I'm doing the
wrong things.

In my apartment, you are a
lover who is also a friend.
You tell me that my bed
is very comfortable and
in the morning we share a
bowl of granola

In that dream I had, you
are a gardener who is also
ecstatic to see me. It
is my favorite time of
day when everything goes
blue.

In my heart, there is no pretending.
Here, I am watching your
hands pack hundreds and
hundreds of envelopes.

7.13.18

GOOD MORNING MY LOVE
News reports that traffic is something or
the other but neither of us needs to
know that anyway. A much better
news update would be to tell
us when the sun sets so that we
can plan our days around THAT.

GOOD MORNING MY LOVE
I'm like an air horn or a siren
that arcs through every wavelength
to make sure each one knows
how much I

GOOD MORNING MY LOVE
At some point do love poems become
boring? Does coffee become boring? Does
the way you look at me ever become
boring?

THE ANSWER IS ONLY NO
I think poetry is only bad when it
doesn't understand itself. Sometimes
I feel like bad poetry. Today I
feel like a satellite with an air
horn taped to it, circling the
Earth on one sustained note of

GOOD MORNING MY LOVE
GOOD MORNING MY LOVE
THE SUN SETS TONIGHT
ON YOUR SHOULDERS.

8.8.18

in the heat of summer
you tell me that you're worried
that at Christmas
you'll get me a gift so terrible
that i'll leave you

as you bite your nails over this
and look out the window
i'll hide one hundred envelopes
throughout your apartment
(one in your dresser,
one in a book you'll never read,
one in the pocket of a
favorite dress)

each envelope contains a single card
and each card contains a single word
and one day if you find all of my notes,
you can arrange them around you like
a paper whirlpool and see that there
was never a reason to be worried
about Christmas

it spells the sentence of me walking
beside you ("you are, you are, and
that is gift enough") it spells your
glasses of water left forgotten
on your windowsill, it spells the
peace of your sleeping face,
("you are, you are, and that is
gift enough")

i've already hidden one hundred
but i know you could use
one hundred more
but know, my love, you will never
ever
find all of them.

8.12.18

What if I called you
my
flyaway
my
faraway

because when
your eyes
flyaway, faraway

all I can
musterup, implement
are my feeble
attempts at
nest-building

to serve as a
net, or a trampoline,
or a landing strip
for the sweet return
of my flyaway,
my faraway.

8.12.18

A secret:
I know that on your flight
from Seattle to the South
you will draw a stranger
in your sketchbook.

Another:
I've told them that you're
coming, so that they
can fix their stray hairs
and wipe the shmutz from
their eyes.

"Sit up straight," I'll
whisper, and they'll look
around the terminal and
see you staring.

"Oh god," they'll think,
"I hope I look okay."
"Don't worry, you will," I say
as I settle their shoulders
and point their chin towards the light.

8.13.18 "Spending Time"

Most of the time I
leave my phone screen
facing up.

I spend my time holding you
for long stretches and
I spend my time walking with you
from place to place
and when you're gone I spend my
time reading and writing with
my phone screen facing up.

When I am alone I
spend my time cooking meals.
I sometimes stay in bed for
an hour and other times
I read for long stretches
until my coffee goes cold.

I leave my phone screen facing
up because it feels like being
in the same room with you.

I know you spend your time
drawing drawing drawing and
scrolling through the internet
and eating fancy toast across
the street.

And I leave my phone screen
facing up because it feels

like being in the same
room with you

so that you can tap my
shoulder for a kiss or
simply look up
from your work
to make sure
I'm still there.

8.16.18

Quickly, a happy nude!

8.18.18

This morning I'm reading (spending time) with
Mary Ruefle, a poet who
tells me about urgency in writing.

(bees, business, bus rides)

(a calendar, an evernote, an event)

(you, asleep in white covers)

Urgency means there isn't enough time.

(my work schedule, my sleep schedule, my love life)

Leaving your apartment is not like removing
a band aid in the sense that I'm always finding
ways to draw out the moment.

(jingling my keys, forgetting my water bottle)

It's still that I am busy so that
I won't be later (spending time).

For me *urgency* means you will never have to guess

(a paper plane catches a draft beneath it)

maybe then, instead of being busy,
I can just be cool, clean air

(in your lungs, on its way, or stagnant,
hanging in your room with the dust)

8.30.18

If you are a ghost
and I am a ghost
tell me why when
we pass through
each other
it feels like
breathing.

9.18.18

It's called lifespan integration therapy,
you can look it up if
you'd like

it's like cropdusting a painful
memory over the timeline of
your life.

i'm not a therapist
so don't quote me on that.

9.26.18

like dominoes
I'm so afraid that
one mistake with you
will become one thousand

and now
in this dark and icy
forest of dominoes
I'm supposed to find
my way home.

10.7.18

o! kind of how
those o.g. poets
would clear their
throats, like how
rappers say "uh"
or "yo" before
they destroy it

o! like when i
look up from tying
my shoes to see
you still bundled in
your sheets (same
white as the
weather today)

o! like a doris day wink
o! like walking a tightrope
over angel falls
precarious but
exactly what
my heart wants.

10.7.18

so, you handed me a
small porcelain cat the
size of a raindrop,

a gift you bought
for me to ward off
evil spirits.

in my life i have used
mustard seeds in only
one recipe, and i am
tired of thinking about
their supposed power.

for some reason we
love small, tiny things

(i usually know
how much they matter but
i am sad at how
often i forget that)

12.15.18

I smooth the ground
with a flat stick
a cream of concrete
for wooden slats, polished
and finished with bloodred varnish,
chafed with a wire brush,
softened with sandstone,
and blowdried smooth,
danced upon with hard shoes
and slid upon with woolen socks,
topped with a hand-me-down carpet
on which I lay cushions and pillows
and blankets, so that we can
spend the afternoon counting each
other's freckles
held by one another
and the earth.

12.22.18

Your cat avoids my hand
when I approach with
her morning pills

but she dutifully swallows
her medicine, then rolls
over to present her
belly for rubs.

1.8.19

A tiny picnic in a Miyazaki field
where! you and I sit with
baby penguins in our laps,
pointing out clouds and
telling our furry friends that
hope floats like helium but
never runs out completely.

"And!" I continue, aligning
cheek to cheek
with the little bird so I
can see what she sees,
I say "when the gas is
all gone we'll have to
fill balloons with laughter
and the only thing left
to make our voices sound
funny will be the tears
that get trapped inside
us."

And that's when you
slap my leg and say "what
on Earth are you telling
that poor penguin?"

And I'll just laugh
and float ten feet
above our little family
until you finally lasso
me down.

2.10.19

That sunken eye weight
from screens and chips
and blackberry soda

(so the snow says " ")

"It's so quiet out there,"
you are pulling off
your rubber boots,
"I forget
that snow does that"
and
it powders down
my sunken eyes
from screens and
chips
and blackberry soda.

stuck inside means
not stale
but more like
the feeling that I have become
a piece of this
apartment.

2.13.19

For Valentine's Day
what if I just
turned into a foil balloon
in a grocery store,
waiting all day for a sweaty
man to arrive, counting the
bills in his wallet
and looking around frantically
for chocolates or -
me!

FARTHEST AWAY FROM PERFECT

3.20.19

Farthest away
from perfect
we then start
to see the
edge of it.

3.27.19

the most
efficient way
to deliver
information
is to
whisper it
into
each
interaction

(though my
heart does
have a soft
spot for
every
inefficiency)

3.27.19

maybe now
the best thing
is to appreciate
the fatigue
(and lightness)
beneath my
eyes.

3.27.19

They're all here
(back to visit
for a spell!)
"We're proud of
you!" they
say, my favorite
guests, without
worrying about
when they'll
leave but instead
loving their
dishes as I
clean them.

4.13.19

I'm a little irritated
about this quote
from Lord Tennyson's
Wikipedia page:

He turned out
"appropriate but often
uninspired verse".

Sometimes I'm
afraid if I
speak too much
I'll diminish the
weight of my
words

but this is only
true if my words
are saying nothing
when I speak.

4.13.19

CRINGE
happens when
words deviate
so far from
their intent
that it physically
hurts

6.16.19

I don't like
writing poems
very much.

I sometimes
get so sad I
can't feel my
hands.

Then they fumble
for a pen
and bleed excessively.

A kind of medieval
approach to feeling
better

that leaves me
feeling like a
husk,
which is
equal to or worse than
feeling full of
blood.

6.25.19

One of the ways
machine learning
works is that
you need to feed
the computer with
examples:

"Here are one
hundred, one
thousand examples
of what a t-shirt
looks like so that
you know what
one looks like
in the future."

Humans call this
practice, and
practice takes
time.

I have been
juggling for
ten years
now, and I
have to teach
my brain which
ways work and
which ways don't.

I do this through practice,
so that my brain has a
thousand examples to learn
from.

I have read maybe one
hundred books or so,
looking for examples of
how to hold my heart.

When the computer
picks a t-shirt from
an array of photos,
it feels like magic.

When I rest my heart
in its ceramic mug, it
feels like magic.

But it's just practice,
over the course of
generations and generations,
that has helped me be
at home with you.

6.27.19

I remember
how the prickly
surface of the
high dive still
felt slippery under
my toes,

and peering over
the edge felt
like someone had
tugged the silk
of my breath
out like a
magic trick.

Years, decades later,
I found myself at
a cafe with you,
under a gazebo
overgrown with
vines, set at
a white iron
table for
afternoon snacks,

and they served me
a glass with the
silk of my breath
swirling around in
it, a soft, lavender blue
like a clothesline dress.

I drank my
soul back quickly
(I still am
thirsty for it!) and
if you took a microscope
to the cells of my
skin, you'd see their
tiny hairs reaching out
for more.

The thrill of the high dive
is in the decision to
step off its edge,

from the prickly slip
to shreds of air

the scarf escapes
my mouth and my
fingers grasp for it
but it is lost to
the wind like
a letter

and all that's left is

> *one-one thousand*
> *one-one thousand*
> *one-one thousand*

when I bury my face
in the curve of your
neck, I catch my breath again.

> *one-one thousand*
> *one-one thousand*

one-one thousand

and it's as if I have
become the scarf escaped
and windswept
tumbling forever
in your atmosphere.

7.31.19

And so I sit at
the edge of this lake

 pulling up handfuls of
 water to drown myself
 (or clean my tears
 or to cry into something
 that isn't just my hands)

and so I guess one day
I will die (drowning is
how I am imagining it
now) and when I scream
it is only thunder and
bubbles.

 (how long should a
 baptism last?)

 (it feels like I've
 been here for too long)

and my lungs ache and
I'm ready to fill them
with water, but now
my palms are
empty and it's just
me and this lake,
and a deep cold breath
of mountain air.

8.23.19

Here's a terrible secret of mine:
the day I kissed you (the
first first time!) I shook
terribly.

You gripped me so hard
(in case you had to push me away, I'm guessing)

and I shook, my
whole body shook.

(I wanted this so badly)

The last time I shook
this terribly (I've told you
this story) was in
my sparse apartment,
I pushed my lover
away and shook
and shook.

From a sci-fi movie I
watched last night:

"I can feel the fear
you carry with you, and
I wish there was something
I could do to take it away."

From the book I'm reading right this moment:

"Fear is the *ghost* of an experience."

I carry my fear with
me like a ghost
and (embarrassingly) I
fear I might feel
lonely without it.

Picture this: I'm
waiting at a crosswalk,
holding the hand of my
little companion, fear.

But! Back to that moment!
Our first, *first* kiss!
I shook so terribly because
every ghost poured out of me
leaving only light.

DETROIT

1.4.23

you grab me at a party, push me against
a wall
and say
"what if this is the last memory you ever have of me? what if this is
what you remember when i am gone?"

1.6.23

You, an athlete, talk
about winning and
losing when talking
about us.

You are something to be won,
you say, and the winners
disappear.

You say that between you
and me, at any given
moment, one of us
is winning, and one
of us is losing.

"I think I'm going to
win this one," you tell me.

And here I am,
outside the stadium,
cheering for you
all the same.

1.12.23

A blue jay in our forgotten
birdbath,

filled by rain from
the past two days
of roiling storm.

1.19.23

Behind your head
is your grandmother's painting
of a roiling sea.

Reminds me of a fisherman's
prayer imprinted on my heart:

"O Lord, be good to me,
for the sea is so large,
and my boat, so small."

You warm your feet
by an electric fireplace,
but more often you
use a hair dryer,
your little ritual, you say.

"I think I might use
my hairdryer for me feet
just as much as for
my hair."

Behind my head are
garish stripes in my childhood
bedroom, surfaces strewn with
weed, lighters, and books.

"O Lord, be good to me,
for the sea is so large,
and my boat, so small."

If I am a sailor,
then you are a gull
traveling with me,
bemused.

My home, my destination,
irrelevant to our kinship
on this roiling sea.

1.20.23

shaved my balls today
for a girl i've
never kissed.

in the four years
i've lived with the
other one, i asked over and
over "let me
know if you
want me to
shave my balls."

when i finally did
on my own volition:
"oh, I like this."

i'm not good at shaving
my balls i don't think.
hunched over with a
prop mirror, trying to
clear the way to
my asshole.

"he looks like
he has good hygiene"
her friends say.

i hang my head, and
pass the razor along
myself.

1.23.23

"aromantic"
he says
(our legs brush)

1.23.23

his joint tastes like
cinnamon sugar
from his lips

1.23.23

The curve of
the mountain,
its saddle

alight with streetlamps
smaller than birthday
candles.

The twinkle of
descending guitar notes
in my ears

as I crest the
hill to home.

1.23.23

No one should
be allowed to
play guitar for
anyone but
themselves

(Even if I were
talented, I think
you would be
more interested
in sucking my dick
than listening to
me play.)

1.25.23

sat on the floor
next to the space heater

stoned.

my heart
a leaf
on the wind

to resist
would be
to disintegrate.

2.1.23

and when my soul was full
i danced

and when empty
i stopped

2.3.23

An hour and a half
to kill before my
manicure

which I am excited
for (canary yellow
nails)

Imagine if the polish
faded if some
miasma hit me.

Imagine if it
cured me of
something.

Imagine if
it simply made me
love myself a
little more.

2.3.23

I am an expert
in forgetting
your face.

When I run
up your flag
it is merely
its outline

Colors, curves,
but your face
and smell
have fortunately
left me

as I am an
expert at letting
the runoff
find its way
back to
the ocean.

2.3.23

I don't know
who I am
so I have
returned to
the garden
and have
found carrots
and beets and
strawberries.

I don't know
who I am
so I raze
the garden

but I always
will see its
outline in
the dirt.

2.7.23

Lake Michigan
resplendently blue,
so cold
that we can
point out
which chunks of
ice we are.

Your nails, painted
black, in contrast
to mine, painted
canary yellow.

"Goth girl and sunshine boy"
you say.

Your hair, dyed startlingly red,
is how I feel I
have always known you
to be.

My heart, a prism,
refracts all
these colors into
a million more,
shining through
the slats of my ribs,

casting shadows
on our intertwined hands.

2.12.23

what if I kissed you,
sacrificing our brotherhood,

what if our lips brushed
(as a joke)

what if the reason
you visited me was
for love (maybe you
don't know the reason
you are visiting me)

what if I sat here,
listening to you talk
at the lakeside
at midnight until
we part ways feeling
like we have
forgotten something.

the what if's
sustain me, and
allow me to tolerate
an evening with you

without kissing you
without resting my head
on your shoulders
without holding your hand.

you are my favorite
and cruelest
"what if".

2.15.23

tonight
i took
my razor scooter
out at night
to grab a pint
of jameson and a
pack of marlboro
27's, my
personal apocalypse,
my little death,
my self care
and destruction
for the sake
of feeling
like shit.

2.15.23

is 30
old enough
to be
credible
as a
poet?

credibility
for poets
is awarded
only after
death.

living,
writing,
and feeling
so much
is
thankless.

2.20.23

the worst part
of feeling
the presence
of God is
feeling his
absence

when chasing
his presence
with booze
& cigs

and only getting
clammy hands

and the knowledge
that i am
the person
consciously
accelerating
my own death.

2.20.23

no party
only
sad in
search of
what Li Po
had despite
never reading
his poems and
only knowing
that he was
a drunk.

2.24.23

awake
late at night
wishing i was
woven into
you.

myself -
a wiry strand
of hemp

bristly,
pure,

tendrils frayed,
catching pollen on the wind.

wash me,
braid me,

wrap me around your finger
and keep me there.

2.26.23

how to dream about me if you so wish:

1. remember that i am very afraid of household chemicals - if you leave the comet out it will scare me away.

2. find small trinkets that remind you of me and put them in a row on your floor. this is how they pick the dalai lama, and coincidentally this is how i will find you on the astral plane.

3. eat vegetables.

4. hold your hands to your cheeks and smoosh them, because this is me saying "what the fuck, why are you being so cute, trying to dream of me, you SIMP."

5. i'm just kidding but really it's kind of embarrassing to have to resort to this list when the real solution is to be in each others arms. "don't let your dreams be dreams" as they say.

6. what a stupid adage. let my dreams be dreams.

7. my dream is to fly into yours so we can sit on a swinging bench on a porch somewhere, feeding each other snacks and arguing about whether or not we can feed the birds.

8. how embarrassing it all is. i swear i'm much cooler in person. but if i'm this turned around and awkward in your dreams, it means that this list worked, and that we are together for at least another REM cycle.

3.4.23

left the window open
for the cool oakland air
to waft on my skull
as i sleep

today she bestowed me a kiss
as a sunset

neon lit bicycle spokes
flit by us like dragonflies
as we cast stones
into lake merritt

dance with me
on this revolutionary ground
with liquor and drums

oakland bestowed you a kiss
on your virgin skull
and freed you enough
to dissolve on the wind

you and i will die
at the altars of our gods
and we will live,
bloodred as brothers,

christened by this chilled air
and buoyed by the thudding
of our hearts

3.8.23

the movie is about
cars going too fast
and i'm pausing it
every ten minutes
to text you

imagine if you could
drive faster than time
and see what's around
the next corner

i don't have to drive that fast
to know where i will be

i like walking
i like finding a spot to sit
on a secluded beach somewhere
to share a sandwich and a joint with you

i can sit here
completely still
and see the future:

a warm night
strung with lights
slow dancing in place
curved like palm trees
into each other's arms

and i'll quietly whisper
into your ear

i am here
i am yours
i am not
going anywhere

as our hearts
like engines
roar along the coast

3.12.23

i like honey
in my tea
and i like my honeybee

she's a devil
that trips
me up

beware the eyes
she winks with

she fills my cup
and drinks it

3.21.23

Hunched, dry skin, aching
feet numb, back sore,
fingers ache.

Yoga for my body,
wine for my soul,
tugging on my cock
for God knows why.

This holy maintenance
as my organs groan,
as my health is
no longer a given.

Nightmares for my psyche,
shakes and shudders
for my morning bouts of
crying.

It's all catching up to me,
insisting on this holy maintenance,
on an abused cathedral
repaired and restored
on tithes alone.

3.22.23 "Goat I"

The eye of the goat
the *slotted* eye of the goat, with his
Piston-like chewing
and unnerving patience

Halo'd in Gregorian chorus
beckoning in a reverberating
flower of life.

He hums like blood
coursing through sewage lines
beneath steaming asphalt

warbling his inverted gospel,
looming over us, arms open,

washing us in a
sleet of dread.

3.26.23

A dream will stop you
from sinking

like your waist tied
to a weather balloon
as it drags you
through a field
of mud.

It yanks you
so you can never
quite gain sure
footing, the rope
rubs your skin
raw.

But it keeps you afloat
for better or for worse,
my love.

This morning you dream
of cooking me a Sunday
breakfast of sausage
and eggs and a warm
cup of coffee.

But here I am, waking up alone,
drinking poisoned water, and
bleeding out my savings on
faith alone, my darling
weather balloon.

Like a wheel with
broken spokes, I limp to you,
for what else is a wheel
good for.

3.28.23

When you are sick in bed,
this is the best time
for me to win a boxing
match against you

unless you kick me
in the balls

which is warranted,
but against the rules.

I've read that there are
so many nerves in our
stomachs and our guts
that they serve as
a second brain.

"Listen to your gut,"
they say,
"and it will never
lead you astray."

I press my ear
to your second brain,
to hear its disgruntled purr.

"Just you wait,"
she tells me,
"I'll best you yet."

"What's she saying?"

you ask.

"That you need rest,"
I say, wringing my hands,
"and to take it easy
for as long as you need."

A light kiss
to your first brain

a warm palm
on your second.

There is no rush for
you to return to full power,
my darling tyrant.

Let me win
and let me love you
while you're down
and out
for the round.

4.1.23

Thunder,
room goes white
like a screenshot

and I only notice
it's raining
when I look away
from my compiling
code.

It's 3am and
I'm still troubleshooting
(screenshot, thunder)
swapping out the cold tea
for a cold beer.

Writing code is like
tying your shoes with
chopsticks when you
need to run a marathon.

On my back,
lying in bed,
waiting for the
rain to
soothe my whirring
brain.

Rain isn't enough.
Drugs aren't enough.
Sex isn't enough.

Only screaming into the thunder
until it thunders back,

only the paparazzi of lightning
can free these cogs
from their axles.

4.3.23

I'm always checking
my fingernails to
see if they're turning
blue (I'm constantly
afraid that my
heart will stop,
seize, or explode)

I'm checking my
hands so regularly
that it feels
like the idle animation
in a POV video game:

Fronts of hands,
backs of hands.

When I walk I
routinely touch each
of the tips of my
fingers with my
thumbs

to make sure I
haven't had a
stroke.

I have a hard time
telling if it's simply
anxiety or legitimate
worry, and doctors

are seldom helpful
to me.

My beauty, my body,
my mind will inevitably
be taken from me,
piece by piece,
limb by limb

and I'm mourning them
before they've even gone.

A skipped heartbeat.
A numbness in the toes.
Losing my way,
inch by inch, in a wooded darkness.

Do these gnarled and distended trees
mourn their limbs as I do?

Or can I learn
to persist and decay
in royal splendor

before the beetles
and maggots
take hold.

4.3.23 Ice Cream Haikus

soft serve ice cream cones
handed through a windowsill
weather won't deter

vanilla, chocolate
or a twist of both of them?
cake cone or waffle?

the party rages
they drink at the bar next door
on a Monday night

no customers here
for long stretches until BOOM!
all here with their moms.

4.7.23

Cherry notes in my coffee
hands so cold my
phone tumbles out of
my hands (in slow
motion) onto the
sidewalk.

One bounce, two bounce.
God bless its protective case.

Fight (surviving the
craziness of moving into
my Detroit apartment
without a car)

and Flight (being afraid
of meeting my girlfriend's
parents).

Nicked my balls this
morning while
shaving them.

Smells like cherry detergent
in the Amtrak lobby air.

"I admire how adaptable you are,"
she tells me (each time we
have met, it has been in
a different city).

Every week I lose a dozen followers
as they realize I am no longer
dating their favorite influencer.

Every week I unfollow someone
who reminds me of my previous selves.

Becoming, unbecoming.

I lie awake at night
and imagine disappearing
limb by limb,
first one arm, then the next,
then my legs
until only the raw gemstone of my
heart remains.

"I admire how adaptable you are,"
she says, turning the stone in
the light.

"Let me tell you a secret," I say,
leaning across the table. "One of
my lifelong dreams is to disappear."

One bounce, two bounce.
A gemstone lost to sewer grates.

On this train
I am the most anonymous
I've ever been.

Limbs don't disappear
on their own,
you have to cut them
off cleanly, the quicker
the better.

I imagine stepping off
this train halfway to
my destination, and going
south,

to vast expanses of corn stalks,
walking with my arms extended,
hands brushing the anonymous
crops until I lose myself.

"Let me tell you a secret," I say
to the bone dry dirt, "I have
always dreamt of a house in
an expanse of grain, a
humble wooden place, splintered
but warm, a place where
I can sleep all day and
wait outside all night
gazing skywards, waiting
for angels."

I wake from this dream
and find myself back in
the cherry-smell of this
Amtrak lobby, with a
ticket with my name on it
and the words "PROPER IDENTIFICATION
REQUIRED FOR ALL PASSENGERS."

God bless
my
protective
case.

4.14.23

Grandmother turns her
baubled head, hair
gaudy, doneup, and grey.

(Somewhere, tucked away
in a closet with rusted
tins and dusty matches,
a face struggles against
fishnets)

"My response is genuine,"
Grandmother croaks, "This
is real, and true,
a product of what I
have seen."

Her head never stops turning,
nor do her eyes, and her
mouth, agape, is hungry for
something.

(The face is attached to
spokes of legs, spinning,
fighting against the netted
threads, undulating like
a feeding frenzy of fish)

"This is real," Grandmother croaks,
rising from her rocker, each
orifice in her wrinkled skull
a growing abyss.

This is when I wake, gasping,
at 2am in an empty apartment,
the night air gently ebbing at
my curtains.

It's the air, I tell
myself, letting my sweat chill my
armpits.

My ears are acute for Grandmother's
voice on the wind.

I hear moaning and creaking beneath the
floorboards, not with my ears, but with
my heart. The ground is drenched in
petroleum and blood.

Many restless nights to come,
I mutter, tucking myself in, turning
on my side and smelling the air that
wafts in.

The unrest of this contaminated soil
feels like a kind of weather -

we can curse it,
fear it,
bear witness to it as it
passes through.

(I imagine it like a rippled eclipse seen
from beneath the ocean)

"We are in dark waters,"
I mumble to myself, drifting back to sleep.

Grandmother's words hang in the

silence. Somewhere,
a head atop a wheel of
spinning legs, struggles against an
unyielding lattice of threads.

4.14.23

Bear versus human:
Bear wins.

I don't know as much about
animals as you do, but I
know that much.

Swordfish versus human:
It really depends.
I've heard stories,
I've seen how large
swordfish get.

Head versus heart:
Heart always wins,
though head puts up
an honorable fight.

Chocolate versus vanilla:
Why the fuck are we even fighting about this?

At the bar, you stir your
drink with your little
swizzle stick, and you
tell me in spectacular
detail which animals
would maul me and
how.

Which ones would chew me up
and spit me out,

that kind of thing.

Poet versus park ranger:
…
This is when I snatch
the swizzle stick and
poke ya in the belly
with it! AHA! Touché!

Nature versus nurture:
kiss me instead.

Lovebug versus honeypie:
Both are sickening.

Sexy mysterioso versus hot ass:
LET'S GET READY TO
RUMBLLLE!

After a cigarette and
an orange juice, I'll gently
scoot you out of bed to
take you to my favorite
fight in the world.

Wrap yourself in a blanket
my love, it's late and
it's cold out, we'll step
down through the brush
on a narrow trail until
we hear the crunch
of pebbles and the
lapping of waves.

My arm around you,
I'll point in the
distance to the sheer
cliffs silhouetted

by constellations.

Waves versus rock.
Land versus sea.
The oldest cage match
I know of.

I love you not because
one of us will win,
but because our edges will
ease into sand.

You're cold, I know,
so I wrap the blanket
'round both of us.

We'll find a log
of driftwood to
perch atop of

and share a bag
of Gushers.

There will always be a war,
so long as we are warm.

and even in peace,
there will still be
swizzle sticks.

In your ear I'll
whisper that
I'll always be
the winner

and if you disagree,
 fight me.

4.17.23

My hand cupped
against the back of your
head, guiding you to
your drink.

You can turn away
or push against it,
and I'll gently
(but firmly)
guide you back.

You like sticking
your hands into pies
and climbing into
places you don't belong.

When I spin you out
on the dance floor,
I'll tug you back
into my arms.

I can feel you melt here.

They've all let you get away
with too much for too long.

An undefeated wrestler must
love to finally be pinned.

Hand pushed to ear pushed
to floor.

Must be fun to reach
for the matches
and to have me
catch your wrist.

Be good, my darling.
I might be the
only match you need.

4.21.23

He points to a falcon's roost
in an old cathedral,

"The talons don't kill,
it's the impact."

A burst of feathers,
a severed wing.

Age has slowed me some,
and I'm afraid to
turn around and see
what I have left
in my wake.

4.21.23

When I sing you a
lullaby, my darling,

does my sadness
make it sweeter?

Dark chocolate
or
birthday cake?

Whiskey
or lemonade?

Does losing an arm,
then another,
make me cherish
yours, draped off
the side of the bed,
wrists upturned like
dovetailed fish hooks?

Siren lights, red and blue
through a crack in the
curtains

as I comb your soft
brown hair with my
fingers.

If sleep eludes me,
I'll use this time to

protect yours -

dream of us skipping
rocks at a sky blue
beach somewhere

untouched by loss.

Tiny crabs wander by.

4.24.23

nothing worse
than a splinter
in the skin,

hands bound
behind this wooden
chair,

what's worse
about a splinter
is the care
it takes to

remove it.

hold still
a moment
as I hover
over the
breach.

hold still
as I administer
the care.

the silence here
is delicate
like the dust
floating in this
iron white shaft
of light over

your curled toes.

i take hold of
the shard and
ease it out,
slowly as to
not catch your
skin again.

antiseptic.
bandage,
smoothed over
with my thumb.

it will be sore still, love,
but it will not fester.

i tilt your chair back,
hand on the back of your skull,
and rest you here supine,
your elbows brushing against
the smooth concrete and its grit.

you can see the light
cascading in.

we find peace in
the strangest positions,
like when we raise an arm
in bed
to feel the blood
drain from it,

or when knelt
before a lover.

but today the feeling is different,

(if you close your eyes
it's like you're clasped into
a roller coaster's seat on
its vertical ascent)

to be cared for
whilst so exposed.

the light wanes and narrows,

the high air chills your
skin.

darkness, then moonlight
like silk across your thighs.

you will not go cold tonight,
you know this, which makes
every hour, and every drop
in temperature, that much
more delicious.

4.29.23

There is a bridge
behind my
grade school

overgrown,
hidden,
buried in
thorned blackberry vines, high
above a shimmering,
muddy creek.

If you dropped a
rock from
the bridge, you
could count

 one one thousand

before it plopped
into the water.

Loving me means loving
the time it takes
for the rock
to drop.

 one one thousand

Loving me means
finding me here,
 aglow in sunlight,

a child
peering over the edge.

Loving me means
holding me in your arms
as my bones shake
and as my throat aches
in terror
and anguish
and pain.

> *one one thousand,*
> *two one thousand*

Approach me slow, my love.
I am frightened and
don't know why.
My heartbeat is all I hear.

> *one one thousand,*
> *two one thousand*

Loving me means finding
me here at the bridge
as an adult.

Approach me slow,
hold my hand softly,

and let the creek
babble beneath our
dangling feet
as our tears count

> *one one thousand*
> *one one thousand*
> *one one thousand*

5.1.23

She's the empress
of the animals,

flanked by them all.

5.3.23

A tape measure
laced around
your neck.

A photo tucked away
in your wallet.

Turn to laugh into
my shoulder as
I sneak a finger
through your belt
loop and tug.

So close
I'd call it
snug.

5.4.23

Splintered wood and
flaking paint and
crooked steps and
twisted branches,
vines overgrown
into windows,
slats hanging
by rusty nails
and shards of
glass caked
into wiry lawns.

Boarded windows
and fallen-in rooftops
and charred houseframes.

Punctuated with sparks
of solar, paint, spraypaint,
murals, string, statues, signs.

Vibrant rainbow polkadots
amidst the green
and grey.

5.10.23 "or maybe"

I.

or maybe
stalling is
the catapult
into eternity

and when
the car
stutters
that's when
we launch

through the
windshield

because suddenly
stopping was
never part
of the plan.

II.

or maybe
she was
killing me

with her
soft words
her devious
hands wrapped
around me

sure why not
catapult and

send me through
the windshield for
the delicious
shock of it all.

III.

or maybe
this was
eternity
in its
constellation
and panic

a sudden
stop released
me and
she still
loved the
way her
head
rests in
the cradle
of my
shoulder
despite
the galaxy
ending.

IV.

or maybe
it was perfect
and you
mucked it
up

or maybe

the orb
was shattered
by chance

or maybe
we all just
didn't do the
reading

or maybe I
just can't
be the person
you need
me to
be.

5.11.23

or maybe
we could
kiss beneath
a flowery gazebo,
my eyes
are always
streaming with
whitewater tears
they never stop
their outpour
especially when
I am here
in a daisy crown
lips docked
on yours.

5.11.23

or maybe
I am lost
in a labyrinthine
cave, a
dizzy spelunker
out of a horror
film, she ricocheted
or echoed against
the dripping wet
granite, red layered
rock that is too
cold and too
solid against
my wandering
hands in
the impossible
dark, like
blindness.

5.11.23

when I wake
in the middle
of the night

and reach for
your arms,
cool and soft
like a breeze

when I turn
left and right
searching for
the crescent
of your body,

when I curl
so tightly into
the empty space,
creating a whirlpool
in my sheets

this is when I
miss you most, in
a reassuring
comfort of
absence.

5.15.23

uh oh
oh no

she lilts
into the
room like
a tulip petal
through an
open windowsill
into a softly
clattering kitchen.

uh oh
oh no

I really
should be
catching
my bus
instead of
lingering here
for the
music of
her voice.

5.15.23

thinking about
the black crescents,
the French tips
of her polished nails
wrapped around
the neck of
a wine bottle
as she wrestles
out the cork
with a bobby pin
in her teeth as
her bare arms,
tattoo'd,
wrench the
cork free,
my love,
my darling,
she hands me the
bottle as she
puts up her hair.

5.16.23

slumped against
the bus window
watching houses
go by:

one overgrown
with grass,
one blackened
and charred,
one with an
enormous sculpture,
a bust of a
cow's head,
one with
neon orange yarn
bursting from a
window, pulled taut
across the frame,
ones painted
completely pink,
ones with words
spraypainted on
boarded doors.

whipping by,
house, house, house.

5.17.23

or maybe
we all
forgot where
we were
supposed to
be standing
like chess piece
men, facing
each other
in the direction
of our gods,
unmoving,
the wind
weaving leaves
between us
like salt.

5.17.23

heard that
you were
visiting in
the piston
rickshaw of
the crook
of my arm,
live here
with a pepper grinder,
suck the dust from
the miniature
ledge of the
crown molding
and send the
sparks
adrift in
sunlight.

5.17.23

I'm not
even trying
she said
as she launched
herself from
the see-saw
directly upwards
before segmenting
into various
mechanical bits
and bobs, smaller
and smaller
until simply
a fine metallic
dust polluted
a square
bit of atmosphere
for precisely
ten seconds.

5.19.23 "Goat II"

the goat
smirks
on the poster
on the building
across the street,
black and white,
shuttered by
passing cars,
not bleating,
not even once,
just a knowing
smile, faced
west.

5.20.23

X, O, X, O

X, splayed out,
your hand of cards,
your tell, the way
your pupils widen
visible even
in the dark,

O, the shape
of the rim of
your glass, filled
with something
fizzy, something
tart, something
sweet,

X, a marker,
like a target,
on your body,
in the soft curves
where my eyes lock

O, a mess you've
made of me,
does it matter,
my hand,
when I know
you'll fold?

5.24.23

but what if
the Earth imploded
on your bedside
table beneath
the lamplight
like a
solar system
like a
nightlight
like a
projector screen
and while
you slept
the world imploded,
sucked into
itself like
an incredibly
dense speck
of dust that,
shivering,
contained
everything
that the
Earth
was and
then we
held each
other, as
atoms or
whatever
we had

been reduced
to for
eternity.

5.25.23

laughter
like
the
tinkling
of
windchimes
from
the
porch
through
the
garden.

5.25.23

An atom
is mostly
empty space
and there
is no way
to know
where exactly
the electron
is, we
only know
the cloud
of its orbit,
we only know
where it is
supposedly
supposed
to be.

You reach across the table
between our coffees
to lightly hold
the tips of my fingers
like someone
who tries to
hold a speck
of floating dust
without scaring
it away.

At any given moment
I am at one of four

or five places

if you spread out
a net
you could catch me.

Nuclear fission
is exactly what
it sounds like:
a center being
broken in two,

creating enough
energy to fuel
a catastrophic
bomb.

Some nights
I lie awake
watching the
blue shadows
on the ceiling
and feel my
heart being
broken in two.

On these nights,
I watch my shows
about scientists
working as hard
as they can to
contain the damage
of nuclear disaster.

Tons of sand and boron
to cover the poisoned earth.

In some fictional universe,

if I were a nuclear scientist,
my job would be to
protect you from
the shrapnel of
nuclear fission -

I'd come home
to find you asleep
on the couch
in front of the TV.

Let me scoop you up,
darling, and walk
you up the stairs.

Atoms were supposed
to be indivisible,
 which is why we
called them atoms.

"a-" as in "not",
"temnein" as in "cut".

"atomos".

As I tuck you in,
your eyes groggily open,
then close.

All this talk of
science is enough to
put anyone to sleep.

If you are ever wondering
where I am, my orbital
cloud is around *you*, my love,

no matter how quickly I

am moving.

If you open your arms
you can catch me.

I slide into bed
and hold you close
enough to keep
you warm.

Let me stay here
one hundred years.

Cover us
with tons of boron and sand.

5.27.23 "The Sailboat and the Orchid"

Said the sailboat
to the orchid

> "I wish you were here:
> you can travel
> for miles and
> never see a
> spot of land."

Said the orchid back

> "I wish you
> were here:
> I am doted on
> in her living room
> and I love
> watching her
> hustle about."

Said the sailboat

> "At night sometimes
> the sea goes still
> as glass and
> you can't tell
> up from down."

And the orchid

> "At night she falls
> asleep with the

TV on, and when
she wakes, bleary
eyed, she holds
her phone to her
face like a cup
of tea."

Said the sailboat

"Some nights I
dream of you
at my helm in
a terra cotta pot,
misted with sea spray."

Said the orchid

"Some nights I
dream of you
docked where I
can see you
through the window
above the kitchen
sink."

Said the sailboat

"The storms here
are terrible, my
hull creaks against
waves that carry
the force of God."

And dear orchid

"The storms here
are cozy, she
huddles around

candles when the
lights go out,
and she wraps
herself in thick
blankets."

Said the sailboat

"When I sink I
will fall to the
bottom of the
ocean where all
lost sailboats go."

Said the orchid

"When I die I
hope I return
to the earth and
help someone else
grow."

Said the sailboat to
the orchid

"I wish you were
here so I could
show you all the
wonders of the
sea."

And the orchid back

"I wish you were
here so I could
show you the
beauty of growing
roots."

Said the sailboat

> "When I find you
> I'll bring you bits
> of seaglass and
> exotic shells and
> strange cuts of
> seaweed from all
> corners of the
> ocean."

"Find me, find me," calls the orchid,
"and when you do,
your voice will be gift enough."

5.28.23

God bless
go hungry
bleed softly
down the
drain.

Wish for
happiness,
hazardous,
live without
fortune, take
a small copper
coin, the
worthless kind,
used to count
our wishes,
take a bite
(like blood)
take me in
your sweatered
arms and
squeeze until
your arms
reach their
ends and
snap.

5.28.23

For the tulips
and the orchids
and the
transgressions
(lines tested)
for the knowledge
and the blindness
and the holding
of your hand
to read your
palm like every
other man who
fucked you, I
cannot be an
orchid
nor a tulip,
I can only
be a throw
rug, spilled
and spat and
walked upon,
but occasionally
appreciated
as essential to
your home.

Phonics can be
the art of
waking up your
skin with the
softest of hums,

I have learned
what the comfort
of rugs do for my
heart and my home,
we don't clean
them enough
or at least
I don't.

The coldness of
hardwood,
of early
morning,
of pruning.

Walk all over me,
and let me rest.

5.29.23

kill me
with a
forklift

eject me
into the
atmosphere

vacuum seal
my heartache
and freeze it

fuck my
eyeballs and
leave me
for dead.

5.31.23

watch a man
walk into a room
knowing that the
room will close
in on him.

watch a man
reach for the
dangling chain
attached to a
ceiling light
and douse the
room in
darkness.

his head is
an empty gourd,
a small dried
pea or two
rattling inside
as, wall by wall,
the room gets
smaller and
smaller.

why would you
love a man
trapped like this,
when he has
nowhere to go
until he is

crushed into jam?

the tungsten bulb
bursts

and the shards
become so small
they lose their
edge.

5.31.23 "Goat III"

Good morning bright eyed
goatsir, my man, my bleating
beast across the street,
you smirking minx, you
well-hung devil, you
cud-chewing monster, you
absolute wretch, you
hay-smelling fart machine,
I love you, give me
a kiss, lean your head
on my shoulder as I
sing you a tune
like the videos I see
on TikTok, greatest of
all time, greatest pleasure
of my day, go, go,
run free in the pastures
of my mind and return
only when you crave to
divest your freedom.

6.2.23

But what if
we were stargazing
and the moon
came down to
greet us and
said "Lo, you
and I are one
step away from
each other and
if we intertwine
our fingers we
can be alit
until sunrise amidst
the zebra strips
of grass."

And you and I
would bleed into
each other like
paint and become
moonlight (sunlight,
once removed) and
if you poured our
paint into a glass
and drank it, it
would poison you
in the most
beautiful way possible,
it would cut you
into fine ribbons that
would unravel into

the cool night air.

Punctual, like an
office shredder, but
with far less blood.

6.2.23

For the love
of God, she
whispered to
her small stone
frog, save me
from every
avalanche of
feeling, blood
cold like snow,
save me from
the fire of
waking, when
my anger has
nowhere to hide,
save me from
my amygdala,
roughly the same
size as you, friend,
with a crippling effect
on my heart like
bad weather.

6.2.23

Function, sunlight,
slatted
(like my self hatred)
coming through
the frosted
bathroom mirror
in the early
morning when
awash in
gold I call
myself a
faggot in
the mirror
and sob
and huff
and groan
before leaving,

the birds
chirp at
sunrise (you
say they're "screaming")

when it is
I, in fact,
doing the
screaming
and sobbing
into my
pillow as
each muscle

relaxes, releases,
sending a
tidal wave
of grief
like cold
radiation,
my hair won't
fall out
but my
breath will
leave me like
snow off my skin.

I will sew up
my pores and
turn into a
freezer-burned statue,
each cell ruptured
by crystals of
expanding water,
exploding as the
ice inside me
pushes against
the walls of
my veins until
I unravel into
fine ribbons
on a snowbank
or a chilled
creek somewhere.

6.5.23

On God, she says,
with the sincerity
of a paper plate,
I cannot wrap
my hands around
her throat without
hearing that promise,
the first lecture,
the second, the
alignment like
a lightning strike,
"On God" like
a virtuous stab
wound on the
credibility of
my hospital
wound
temperament.

6.5.23

Or what if
we kissed a
rock between
us 'til our
teeth chipped,
what if the
fog cleared
to show us
a sheer cliff
adorned in eagles' nests
what if you fell
and I fell
and caught the
wind in our
breakers and
soared like
albatross, splintering
into shards like
hollow straw,
venerable and
purchasing our
fates in the
ocean foam.

6.6.23

Arc-like
the fountainfall
spark-like
(so bright,
like bouncing white-hot
embers)
chest open, pulled
up by and old
industrial crane
hook, lifted
past the
scaffolding,
why am I
always ascending,
or am I
simply being
pulled out
of the ground?

6.6.23

An elegant hand,
arced, hooked,
bent, wrapped around,
adorned in a single
gold bracelet of tiny
interwoven chainlinks,
sprung up, helixed,
sandpapered to fine
silt, soothed to
vinyl, whiskey,
and shunned of
purpose, later, too
late, cached in
a beast pocket,
soothed again,
never escaping but
hooked and
swallowing
every last
drop.

6.6.23

Did you
know I
loved you
when I
saw the
ground beneath
you shake,
the pebbles
shivered as
you walked
by like a
stampede,
you have that
effect, you
make the
world tremble
as you pass
through it.

6.8.23

Opalescent,
lips curved
around crystal,
around shimmering
abalone swirls,
touched lightly on
the turmeric bellcurve,
humming you to
stupor, humming you
to drunkenness, off
the fallen strap
from your shoulder
forgotten, ignored,
smirking with bright,
shining laughter that
blinds briefly, leaving
an imprint on the
retina, leaving my
hand grasping a
a cold pocket of
air.

6.9.23

Listen, while I've
got you here by
the throat, squeezing
until you cough,
this has never
come naturally to
me before I
met you, and
now all I
know are the
ways to soften
you, anticipating
your secret needs,
are you just
good at telling
me without words,
or can I taste
the melted bits
of you, or are
we just good
dance partners,
tugging at each
other's hands?

6.10.23

Read something
about the shape
of music and
how it taps
into our primitive
feelings, so
different from
words.

Words are like
pinning butterflies
to foam to label
genus and taxon.

Music is feeling
them brush on
your skin.

I like words,
as you know
(they help me
pin down
my butterflies).

You like music
because it
heightens
feeling.

I love people
who speak words

like music -

I want to learn from them
how to
perfectly denote
the taxon and genus
of my love
for you, brushing
it on your skin
like music.

6.14.23

Crossing from Illinois to Indiana to Michigan,
the time zone changes -
we leap one hour into the future.

I wish we could live in that
missing hour, a time lost in time.

I'd spend that time lying next to you,
holding you, chatting, and kissing your nose.

Crossing from Michigan to Indiana to Illinois,
you gain an hour
which you
will likely spend on sleep.

The time I spend sleeping
next to you is never time
lost - it is time I feel at home,
at peace.

Tonight, as you drift off,
an hour behind me, I'll leave
a space in my bed open
and wait for you to catch up.

6.15.23

For me
a single white
daisy, tucked
behind my ear
where the heat
from my temple
lightly cooks it -
the petals brown
and curl while
I spin once to
enjoy its adornment
before it dusts
my shoulders
with ash.

6.15.23

self
protecc
plz
hold onto
the things
that are
mine -
the sci-fi,
the books,
the things
that make
me feel
whole,
cooking at
midnight,
writing poems,
leaning my
head against
the bus window
and letting
music run
the show.

6.15.23

You sent me
a link to a
cushion as
large as a bed,
resembling a
sunflower.

Here, I would
curl up with you,
the two of us
like ladybugs,
and I would
read to you
as the sun
warmed you
to sleep through
the window.

I feel silly, sometimes,
in my softness for you.

I'm happy this bed
makes me feel small enough
to be forgotten and overlooked,
so that our time here
is ours alone.

6.15.23

My softness
is secret, I
keep it here,
perplexed, obscured,
so that one cannot
index or reference
it, but rather
only know
it from whispers,
legend, and suggestions -
this is how I
have always protected
my softness, and
I prefer its hints
until a boat crashes
into it, breaching
the dams and
releasing it in
full force in
agonizing embarrassment
and lust.

6.16.23

Open your
mouth and
send your
tongue forward,
here I place
a gold coin,
here I place
a sentinel,
here I curve
your face
with a soft
angle like
I always do
in habit,
I paid my
balance, I
coursed you,
I flexed into
your pain,
your pleasure,
I carried this
clock on my
back through
the woods.

6.18.23

Open
mouthed
or
not
pulled up
drained
enough
salt
wash
lips
cracked
savory
pain
if
she
only
knew
how
much
I
missed
her
touch.

6.19.23

Softness of
skin - examining
my hands,
inexplicably blue
as I emerge
from the shower.

Lying in bed,
phone in hand,
waiting for
texts from you,
joylessly watching
tiktoks in the time
between messages.

Pictures of
your legs, feet
in fluffy white slippers,
sending my
body into
flexing aches
for your skin, your
lips, the curve of
your neck to breathe
in all of you.

6.27.23

A show of
force from
the king,
a barrage
of tulips,
a cascade
of impotence,
an inevitable
wave of
collapse.

7.12.23

When I look up
the song, I see
it's called "Marry
Me, Archie" or
something.

Hold, as in
pause, as in lock
into your pattern,

hold, as in reach
for me.

 Marry me, Archie.

The tune weaves
through the
air between us,
the hundreds of
miles of air
between us.

7.13.23

If a stop
punished us
in the medieval sense -

If it cast me
across a table
and released
the butterflies
in me -

Like bats
from a cave,
one thousand wings
roaring together
and spiraling up
like smoke -

Bled out here
you could see
my signal for
miles - it's
the migration
of my heart.

7.13.23

or
curl up
under a rock
til sunrise

or serve
soup,
whichever

revives you -

I've been
dead for a while
now
(corpse-like) and

no lighting or
spells have come
for me -

just a quiet decay, peaceful,
on tenterhooks
for an encore.

7.13.23

from atop
a tall rock
the beetle
sees the
horizon,

a visionary,
room for
only a few
here, hush,

breathe in,
hurry with
an armful
of hope to
the colony,

spill it at
their feet
and stand
in silence,
screaming,
rubbing wings
together, but
no sound
comes out.

carry the little ones
to the mountain top,
show them since
we lack the

words, oh but
here's the twist -

they won't translate
for the others
but rather fly
into the sunlight,
an armsfull worth
of hope

leaving the first
beetle alone atop
the rock to watch.

7.14.23

Money
and
steel
folded
clicked
in the
tiny screws
of the clasp
that flips
open for
freshly
printed
cotton,
pinched
and
released
to the
wind.

7.17.23

For naught,
she examples
her hands in
constellation form,
she pleaded with
her fates to
re-weave and
untie the web,
but every leaf
that fluttered
by (like oracles)
sang irrelevance,
sang too large,
why, begged the
girl, am I
so much smaller
than the wind?

7.17.23

For naught,
she hurt her
tunic, rent
it for warmth,
sang it for
money, and
then was left
naked, clothed
in fluorescence,
burning, pink-cheeked,
and swallowing
rock
after rock
after rock
for naught,
for nothing,
for the hope of
feeling like a coin
at the top of its
arc.

7.19.23

Peeking under
my skull at
all the critters
scurrying about,

I hunt for
their directive,
unfocus my
eyes and try
to see the
gestalt of
their squirming.

I arrogantly
think I can
outsmart my
subconscious -

but bugs and vermin
will always outnumber
and outweigh the
efforts of men.

7.24.23

Grasping at air
like holding a phantom,

I wish I could trace your outline with
molten steel so that
when it cools into
your silhouette
it would feel
like you are here.

What they don't tell
you about love's arrow
is how much you will
bleed.

8.17.23

When I say "apple"
and you think of
an apple, this is
a great achievement.

Actors train themselves
to imagine the apple
so clearly that to
them, it is real.

Children, when they
imagine the monster
under their bed, they see
it as clearly as actors do,
I think.

If I dream up a home
and a life for us
and tell you about it
over the phone when you
are hundreds of miles away,

If we can see it as clearly
as we see the same moon tonight,
then who the fuck
cares about apples.

9.12.23

I hate
myself in
my reflection
and I hate
the pangs of
memory when
they crash into
me like planes
in the early morning
after I've spit out
a grey mixture
of toothpaste and
blood - absolve me,
string me up with
wire and release me
from my self-inflictedness.

9.12.23

I hate
the flashbacks
that acutely
shock me
while strolling
down the sidewalk
of Downtown Detroit -
potent memories,
erupting like geysers
and scaling my heart
 (I hate you,
 I hate you,
 I hate you).
I tried so hard
to phoenix myself
into something better,
burned down
and rebuilt
time & time again.

The solution, maybe,
is to receive the
blow and coddle it,
catch it in your
chest and to hold
it in your hands,
this glowing hurt,
this iron-hot amalgam
that can only be
cooled by
my own
forgiveness.

9.14.23

Alive, for
better, for
lusting away
at every short
skirt (they're
disappearing
with the
sun) and I
give myself
"grace" as I
insert dynamite
in my sternum,
destroying my
inability to say
"no", but taking
my ability to say
"yes" with it, as
a consolation.

When I see
you (by chance)
I know I have
T-minus 10 seconds
to let you know
I'm extending my
hand to be yanked
away to anywhere -
my dishonesty will
always cut these
roads short,
my life is being

captained by
someone, and only
sometimes it feels
like me.

9.15.23

I take a
supplement for
neurogenesis, hoping
it will make me
smarter - a small
pill of powdered
Lion's Mane mushroom
that supposedly has
brain benefits.

I asked a
friend over lunch:
"Who do you think
is the smartest
person to ever live?"

and I barely care
about the answer
anymore.

9.25.23

Illusory fog
hanging above
buildings and offices
and a cold, wide,
empty four-lane street.
Your fight is bloody,
ripping at unknown
skin for the sake
of discovering
what's beneath your own -
Illusory, like hiding
beneath a hat or
a tattoo or a leather of
flesh - what pulses and
wriggles within you, love?

9.25.23

"puppy love" implies naiveté,
and made my neck muscles
tense when your mother
said "puppy love" as in
a wriggling bag
thrown in a river, as
in human love is perhaps
more true, but we all
know we throw our
hearts into burlap bags
and let them drift downstream,
hoping to be found
before waterlogged -
instead, love me like a
sinking stone, and find
me with the other lost ones
in the riverbed.

9.26.23

Every end a fray
like a thread under
a microscope
unless we singe the
ends to make
one.

Will we fray or
singe, my love?

Secure yourself
with a sailor's
knot and
we'll leave
the microscope
to someone else.

9.29.23

watching birds in formation
undulating like waves,
as they pass above
a diffusion of white -

when I was ten my
father took me
up the trail to the
spot on the mountain
where the birds filled
the sky like a plague,

spinning in formless
tornadoes as the sun
set rhapsody.

Migration as a form
of beauty, as my
perfected fluidity, as
an individual lost in
the flow of my brothers.

9.29.23

Or what if
I leaned in
towards the
musk of your
densely knit
sweater, loden
and rich with
the lingering
smell of smoke,
of rainwater,
of distant and
forgotten deodorant,
trace amounts
of detergent -
is it that obvious
how close we've
sat next to each other,
late into the night?

9.29.23

Or maybe
to placate
my baser urges,
I can bathe endlessly
and stupefy myself
on wine and chocolate
to make merry in
your absence -
the
warmth of my
own heart, stoked
by a recursive
indulgence of love,
in spite of your missingness
and filled in void
with hot chocolate
and carols.

9.30.23

If we
such as
said we
interlaced fingers so
the bend was
or taut with
intertwined our legs when
furnaced and
fathomless she
whispered that there was
mutual
belongingship
gives rise to
or hopes not for
suspicion and
a glance at
or a hidden frown
behind a hand
(chewing)
her love became
squashed or
compressed with
the weight of
or the sanction of
her eyelids -
curse me,
cup me,
send the swirl
of sauce and
the perfect filet,
send it back

and forget it all,
spat up in your cloth
napkin.

10.2.23

On to the
open mouthed
gape for donuts
and pastries and
muffins with large
square crystals of sugar -
hot coffee that burns
the tongue and leaves
a barren bristle of
dead papillae -
everything, to me, is
poison, unseen, in
the pipes that run into
my heart and my lungs
and the shredded walls
of my stomach -
ribbons await, my
body cut to ribbons.

11.13.23

you will never know
the core of a tree
until you peer into its
wound

your hand will
wander down my
back until
it finds
a scar

i will wince
and you will recoil
but
with tenderness
you return
and place your open palm
on the unhealed parts of me

live in my wounds
as an owl lives
in its trees

11.29.23

"tell me a story
that's alive," says
my professor

i submit 600 words

she says "perhaps i
misspoke - tell me a story
that has already been
digested."

i submit 600 words

she says "perhaps i
misspoke - "

"if i may" i interject,
and i tear ribbons
in my arms
and let the
blood swell
her heart
with pride

12.9.23

how beautiful it is
to take complexity
and braid it
into something

my personal complexity
is tangled up
into knots

there is combing to be done

i'll do it for now unless you'd
like to relieve my
hands for a bit

ABOUT THE AUTHOR

Connor Miller is a writer, organizer, and ghost. Originally from the Bay Area, Connor studied writing at Sarah Lawrence College and has worked in libraries and bookstores across California and the Pacific Northwest. He now lives in Detroit, Michigan.

9 781949 127447